Farting Unicorns

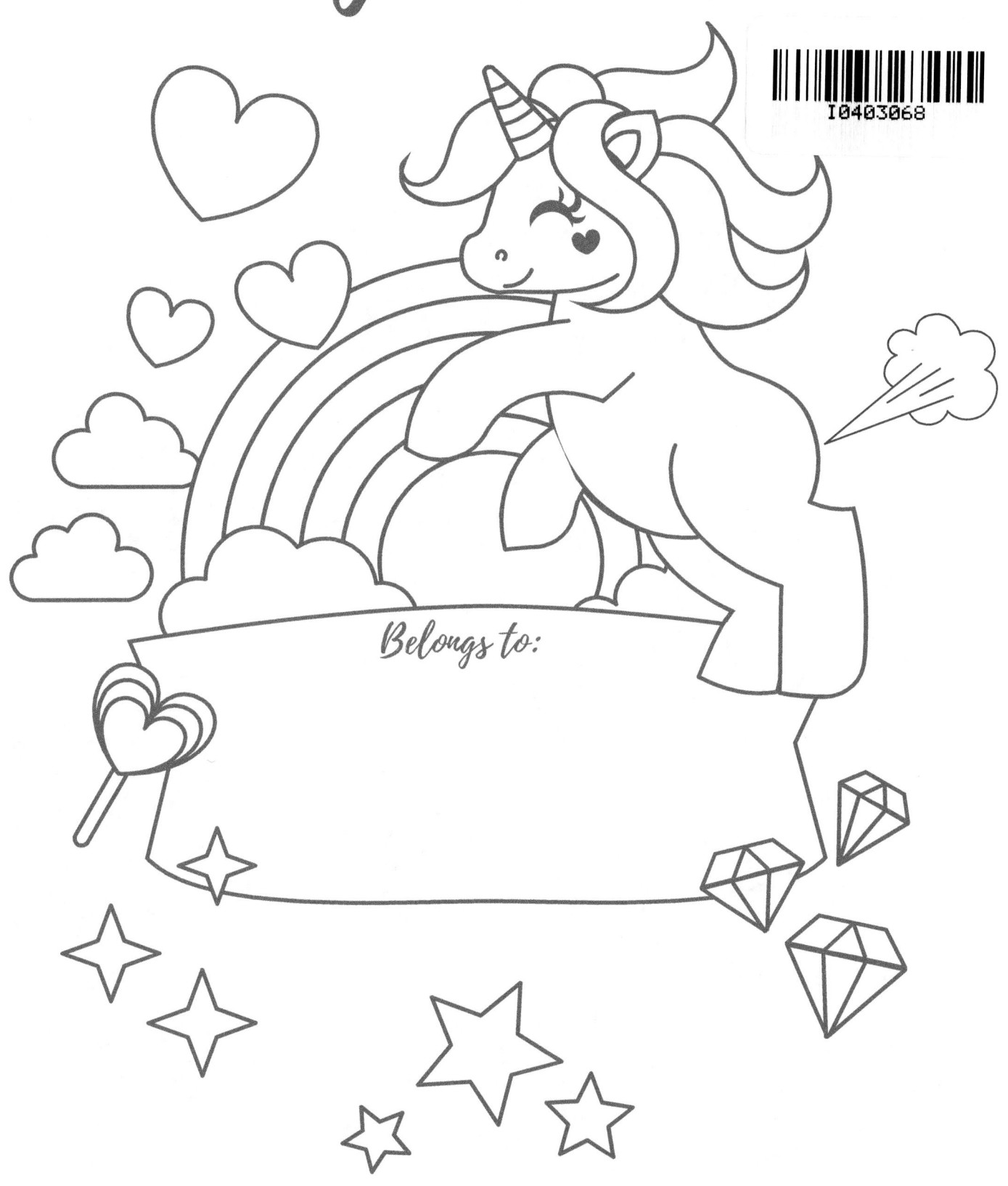

Belongs to:

www.ingramcontent.com/pod-product-compliance
Lightning Source LLC
Chambersburg PA
CBHW080816220526

45466CB00011BB/3588